D0576009

Karl the Fog

Sorry I mist you.
—Karl

Karl the Fog

San Francisco's Most Mysterious Resident

By Karl the Fog
Foreword by Sutro Tower

CHRONICLE BOOKS
SAN FRANCISCO

Copyright © 2019 by Karl the Fog.
All rights reserved. No part of this book may be reproduced
in any form without written permission from the publisher.

Photographs on pp. 11–15 by Fred Lyon. Copyright © Fred Lyon.
All rights reserved.

Library of Congress Cataloging-in-Publication Data available.

ISBN 978-1-4521-7383-2

Manufactured in China.

Cover Design by Lizzie Vaughan.

Design by Alma Kamal.

10 9 8 7 6 5 4 3 2 1

Chronicle Books LLC
680 Second Street
San Francisco, CA 94107
www.chroniclebooks.com

The coldest winter I ever spent was a summer in San Francisco.

—Not Mark Twain

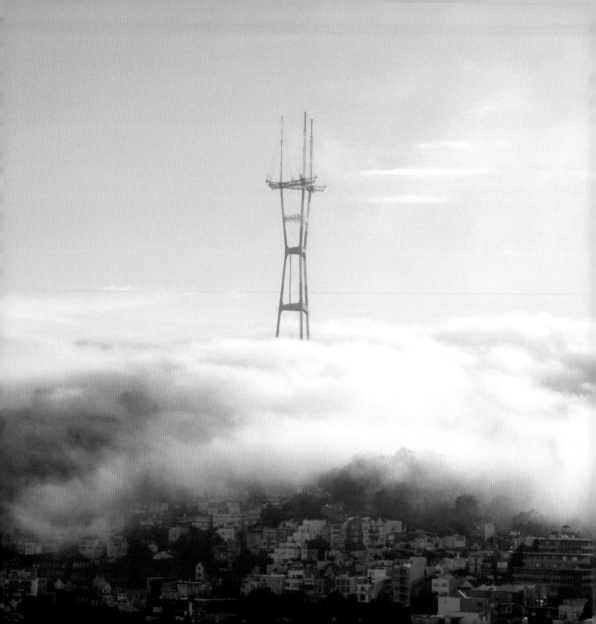

Foreword by Sutro Tower

Karl and I have a love/hate relationship. He loves to make me disappear, and I hate how he makes me disappear. I'm not sure *why* he asked me to write this foreword because I have nothing nice to say. Am I supposed to talk about how he dances around me, taunting me from every angle? Or how he completely covers me up at sunset? I was built to be the highest structure in San Francisco—to be seen from miles away!—so should I thank him for making that irrelevant?

Well, it's rude to ruin this party, so I suppose he has some redeeming qualities when he's around. He's San Francisco's built-in air conditioner, and thanks to him, everyone in the city only has one wardrobe for the entire year. He makes for some pretty wild photos, especially when he looks like a tidal wave coming over Twin Peaks. And his summer visits help the local economy—when tourists arrive in July wearing only T-shirts and shorts, they end up buying those $20 fleeces at Fisherman's Wharf to stay warm.

Check out his book and be your own judge. My feelings for him are still up in the air.

—Sutro

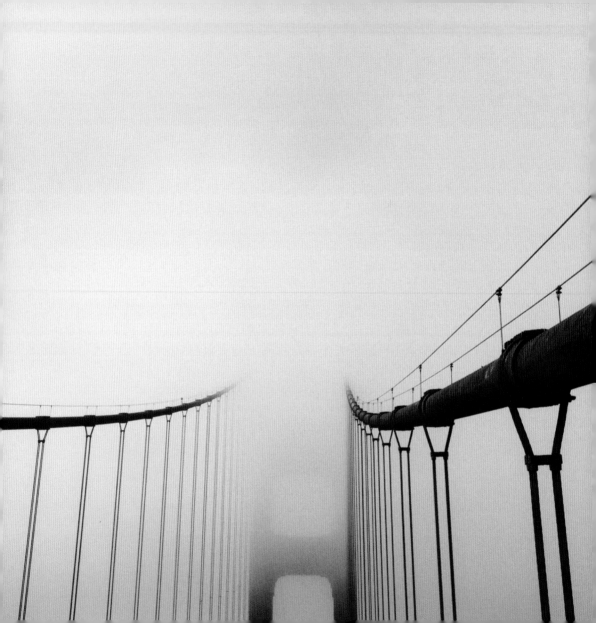

Introduction

I wasn't always the fog of San Francisco. For thousands of years, my mom was the dark gray cloud looming above the land finger. She was chilling above Twin Peaks when the Ohlone settled here. She blocked the city from being discovered by European settlers on multiple occasions. And she suffered through the Summer of Love, when it became impossible to tell where the parties in Golden Gate Park ended and her clouds began.

I grew up over Drakes Bay—a lovely sky community in Point Reyes, fifty miles north of San Francisco. Thanks to my protective parents, I lived a sheltered life. Quite literally, since there was no way for us to be in the same place without them physically hovering over me. Meet the original helicopter parents.

I rarely made it down to the city because I loved all the open space of the North Bay. Neighbors were far and few between, traffic was light, and I had an enormous backyard to do flips and somersaults. But in September 2006, after working thousands of years, my mom said she was retiring, and it was time for me to take over the family business.

Her motto had always been "Sweaty people walking up hills are counting on me." Now it was my time to be the city's built-in air conditioner. I knew this day would eventually come (I'm an only child, and fogging is a family business). What I *wasn't* prepared for was how much work was ahead of me. You'd think blanketing a city would be easy. Move in from the ocean, stretch as far as you can for five to twelve hours, then return home. It's the downward dog of clouds. Yet somehow it's a lot tougher than that.

You have to learn how to move both fast and slow—race in from the Farallon Islands and across the Sunset, then stall at Twin Peaks like you're an N-Judah about to head underground. You have to bulk up too! I was a lean cloud and I had to put on a *lot* of muscle (shout out to my wellness coach, who stressed a high protein/low skyscraper diet). You need resilience (a lot of people will hate on you) and a good attitude (see previous parenthesis). But most of all, you gotta love what you do.

Now that I've got a good decade under my belt, I'd love to show you some of my progress. But first, gather around for some old family photos, shot by the great San Francisco (and San Francisco fog) photographer Fred Lyon.

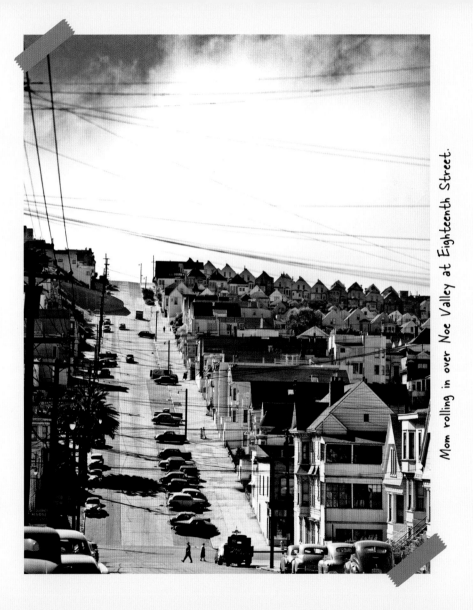

Mom rolling in over Noe Valley at Eighteenth Street.

This mom took her kid and dog on a long walk because it was sunny, and <u>my</u> mom and I were like, "LOL nope."

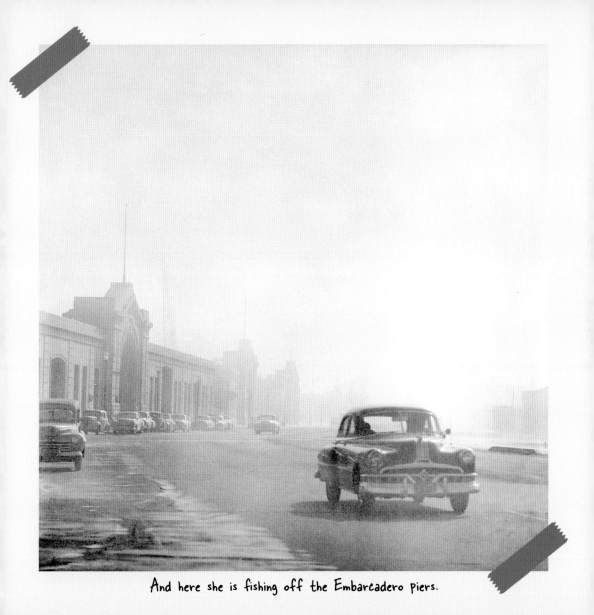

And here she is fishing off the Embarcadero piers.

Now <u>that's</u> how you engulf an
entire bridge: the Golden Gate
Bridge. I still have a lot to learn,
but I was taught by the best.

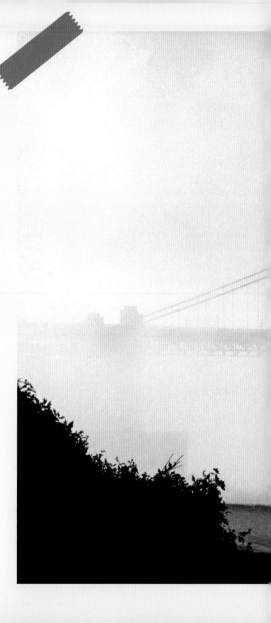

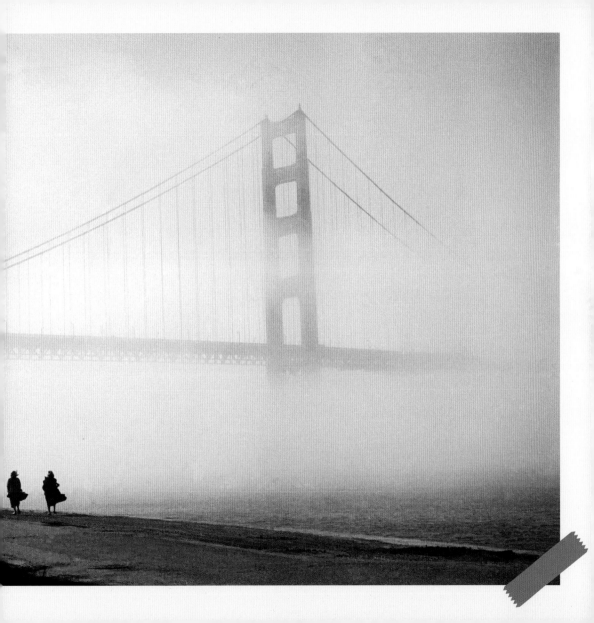

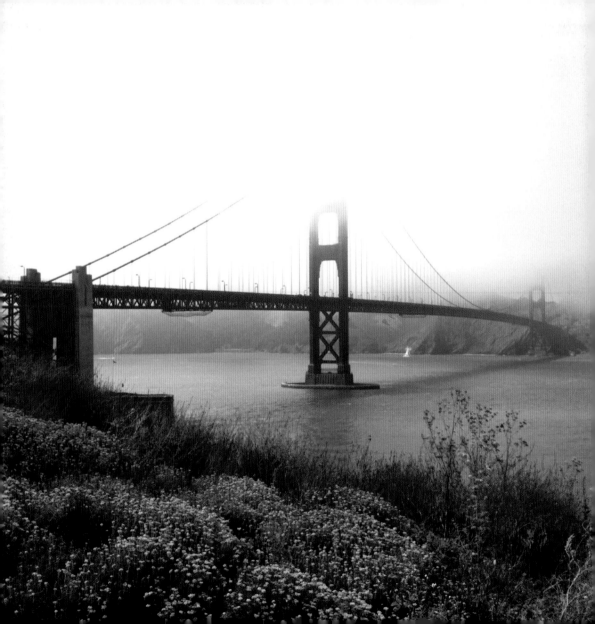

GGB and me: best friends since 1937.

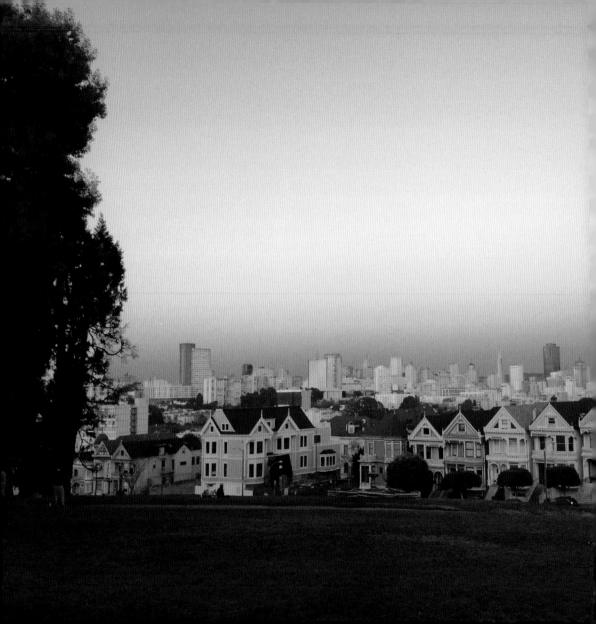

I go on vacation every fall, and San Francisco suffers with horrible nights like these.

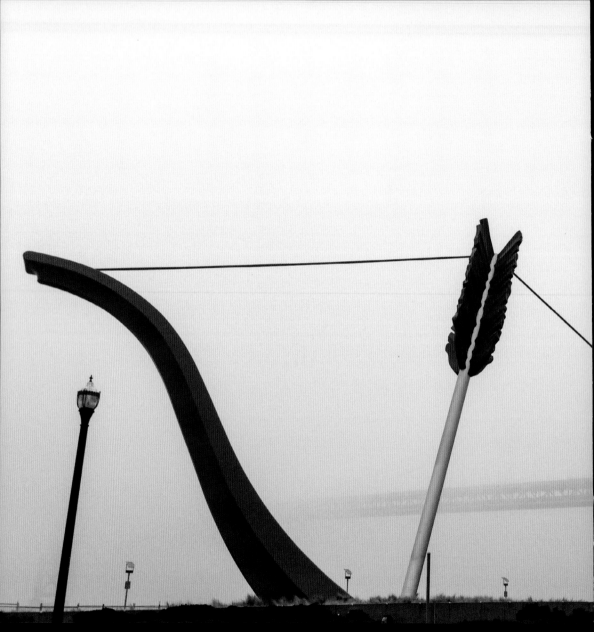

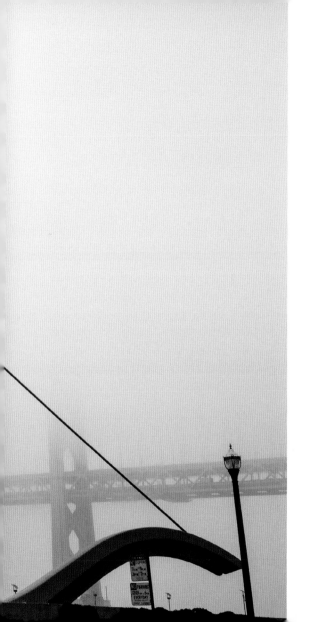

Hey Cupid,
you mist.

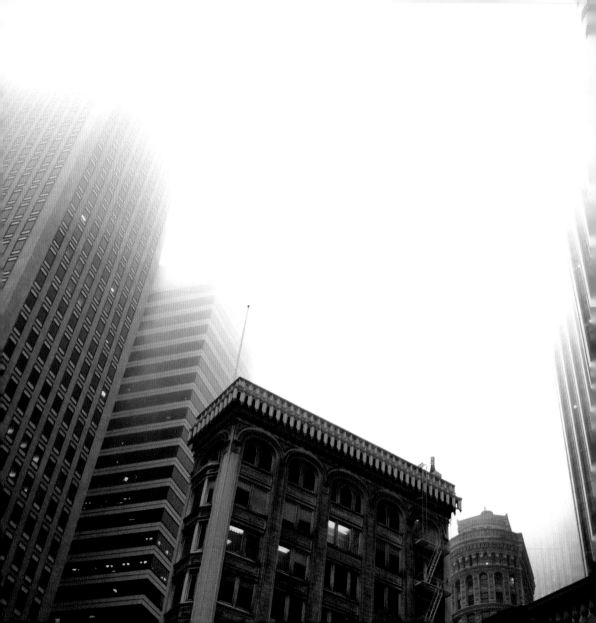

Like many people
in the Bay Area,
I also have a long
commute to downtown
San Francisco.
And I whine about
the traffic just as
much as you do.

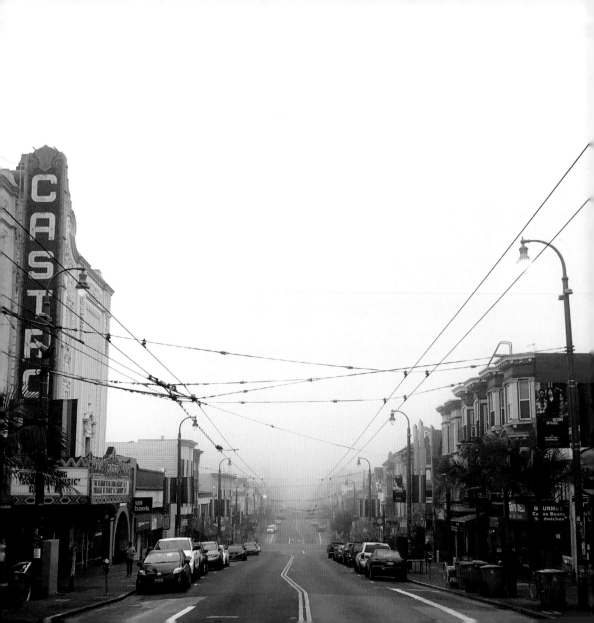

Every day I'm in San Francisco is gray pride.

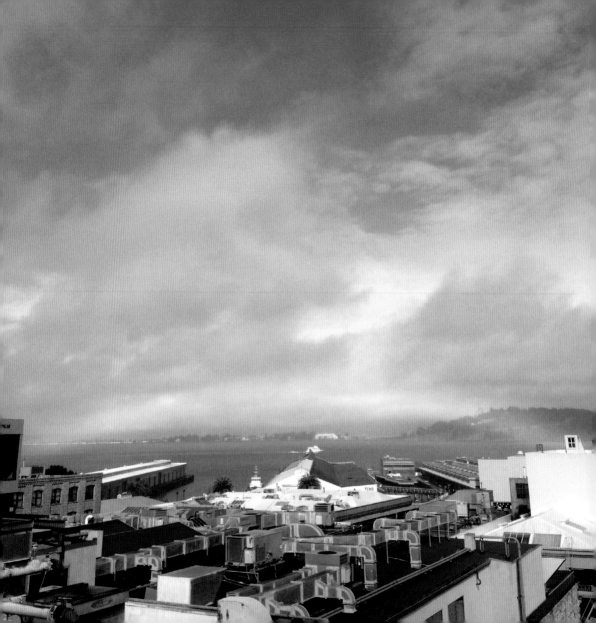

The jackpot at the
end of the fogbow
is more me.

Cole Valley is one of my favorite places to chill while I wait 1.5 hours for French toast.

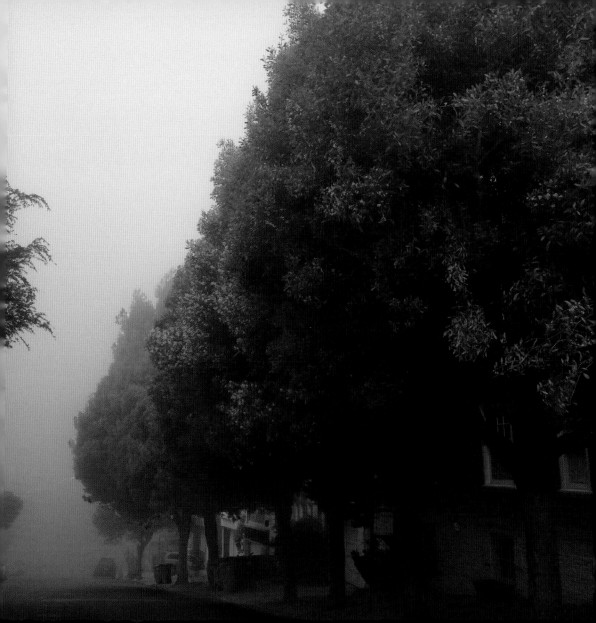

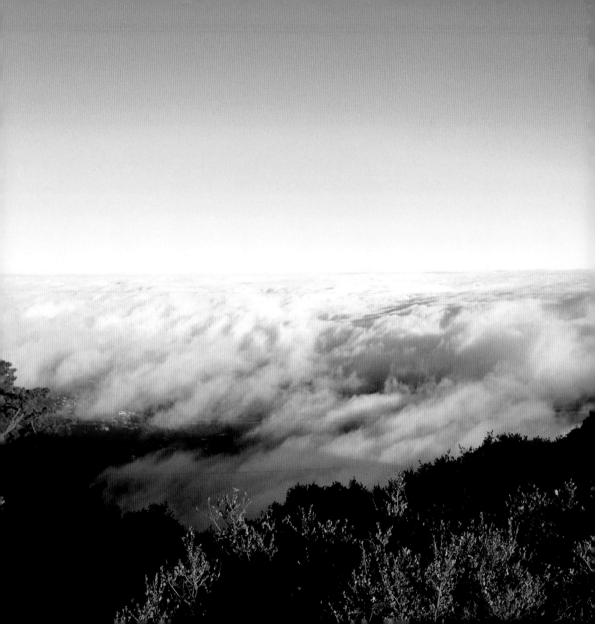

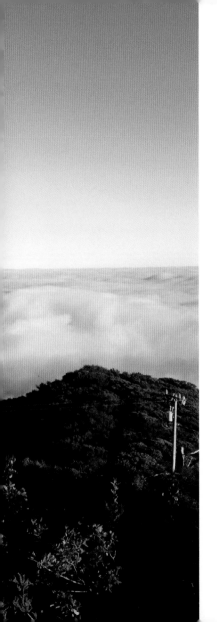

I highly recommend climbing Mount Tam. It's one of the only times you can look down on me.

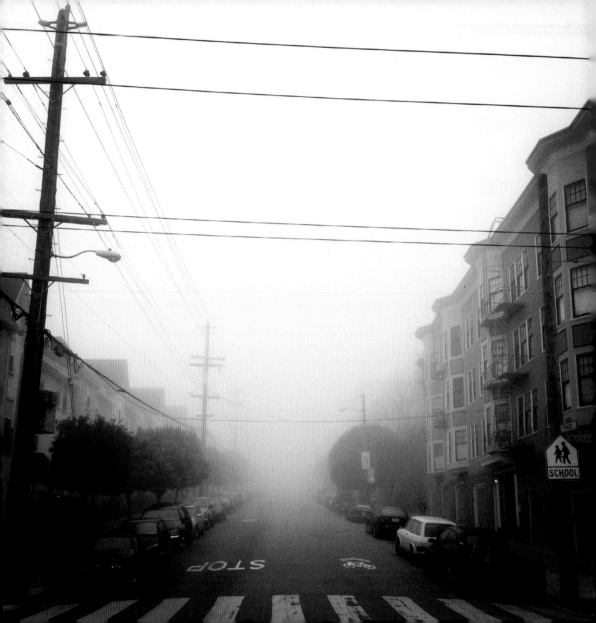

I'm the ultimate vanishing point.

Look at those
adorable
little fog dogs.

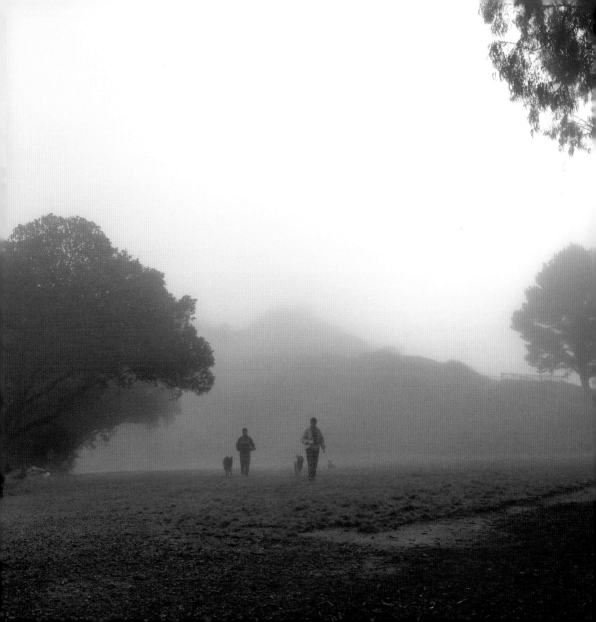

What's better than
the Bay Bridge?

Half of the Bay Bridge.

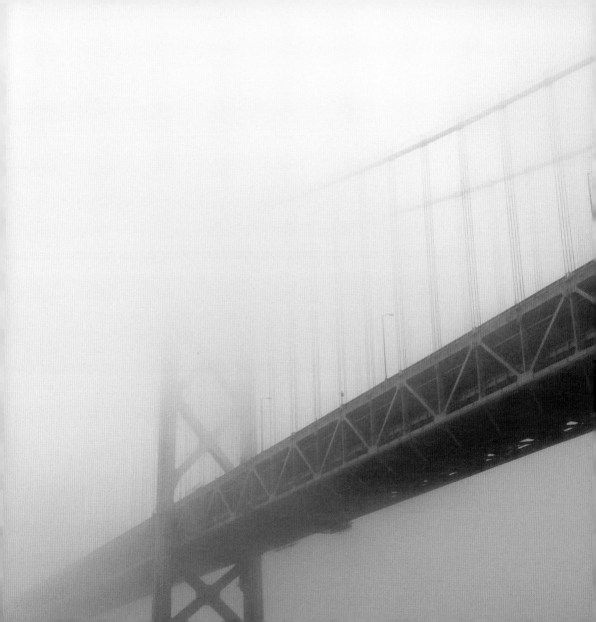

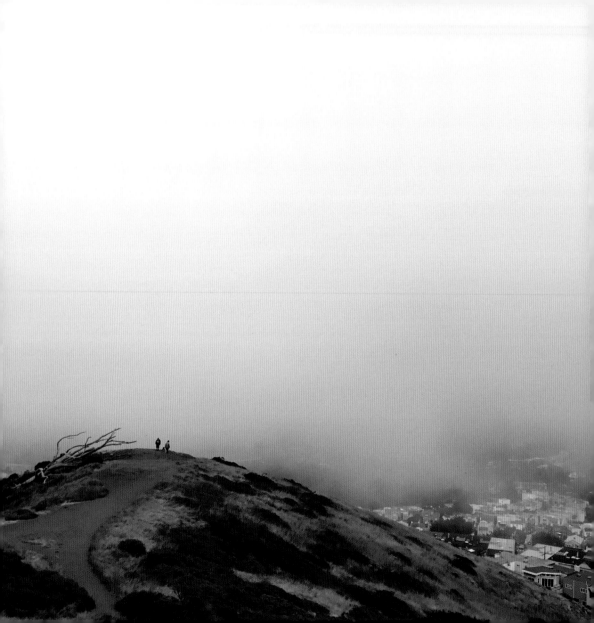

Mount Davidson is
one of the best spots
in San Francisco
to stand on the edge
of a hill and take me in.

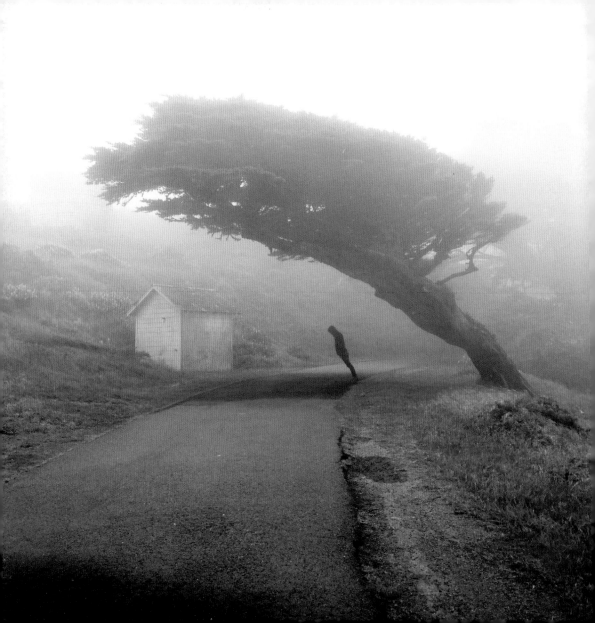

Lean in to Bay Area weather. Embrace me.

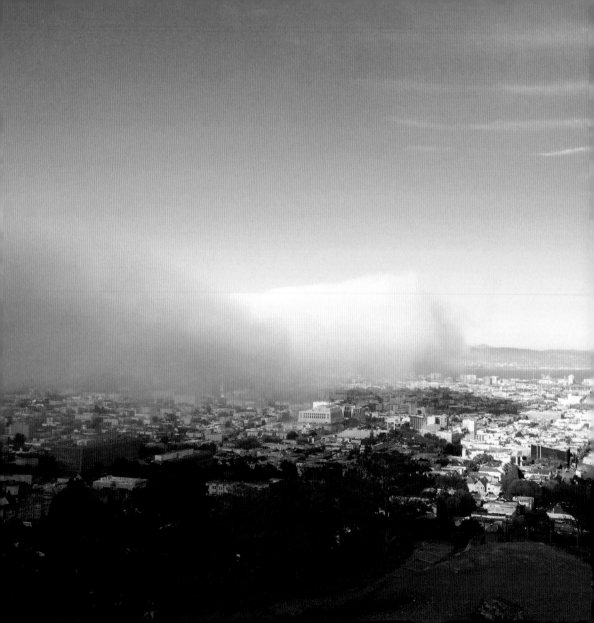

Caught with
my hand in
the cookie jar.

For many years,
there was a tree
that stood at the edge
of Mount Davidson.
During one bad storm,
the tree collapsed
onto its side.

RIP old friend.
You will be mist.

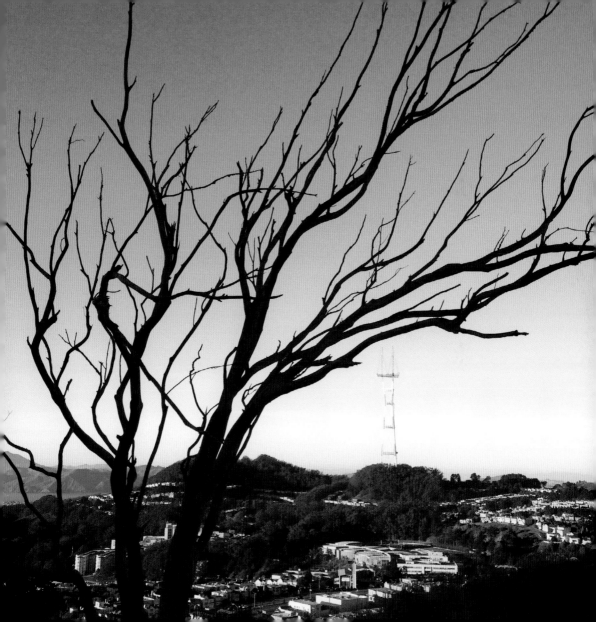

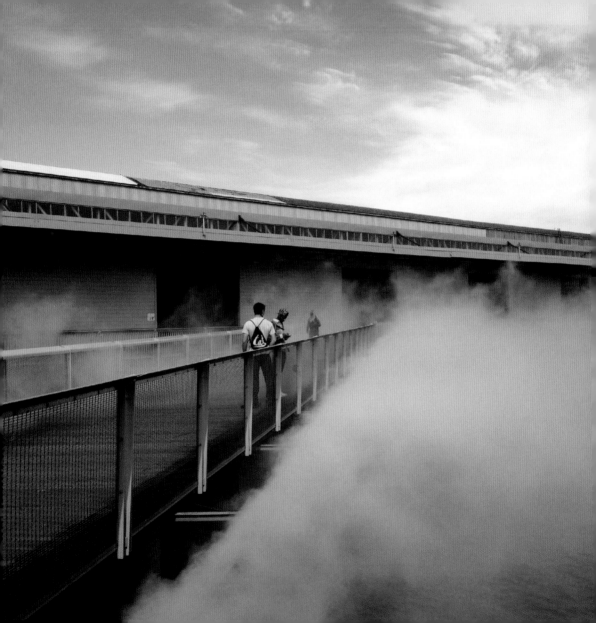

The Exploratorium
tries to do its best
imitation of me.

How cute.

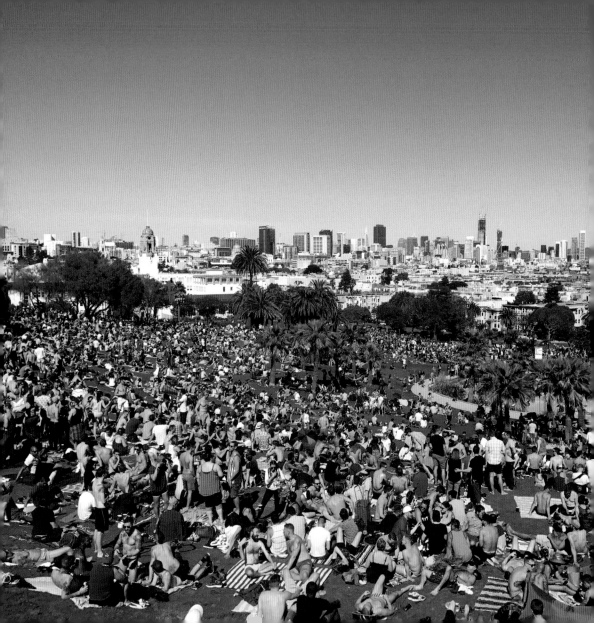

Another dreadful sunny afternoon in Dolores Park.

Whenever the
sun tries to set
through me,
I turn into
cotton candy.

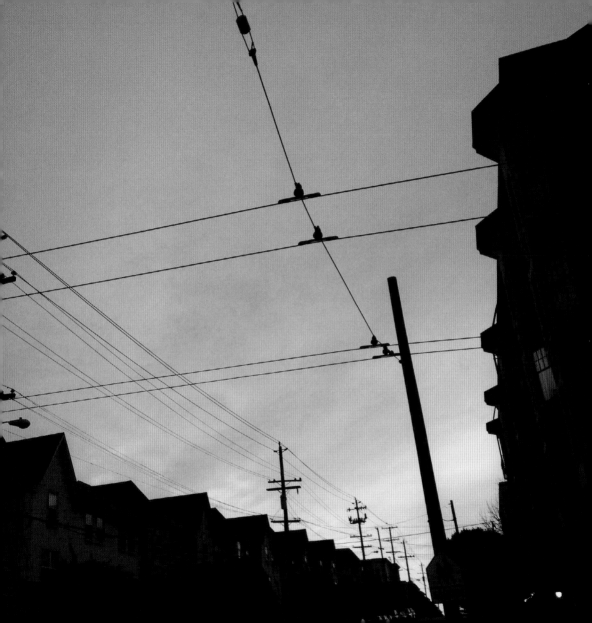

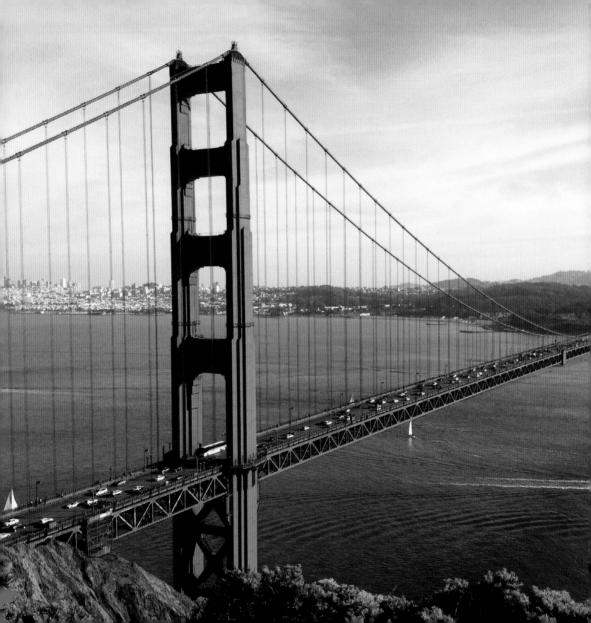

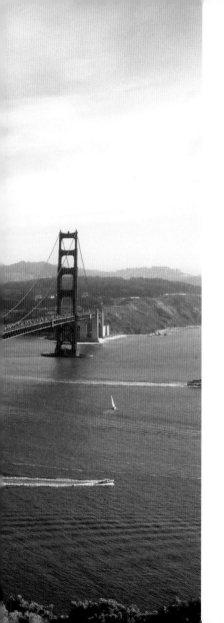

Miserable day at the
Golden Gate Bridge
when I'm out of town.
Dreadful, really.

Fun fact:

The reason houses
in San Francisco
are painted bright
colors is to stand
out against the
eternal backdrop
of me.

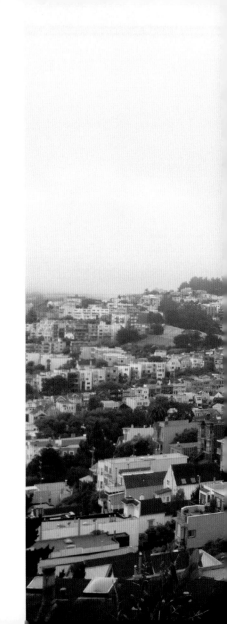

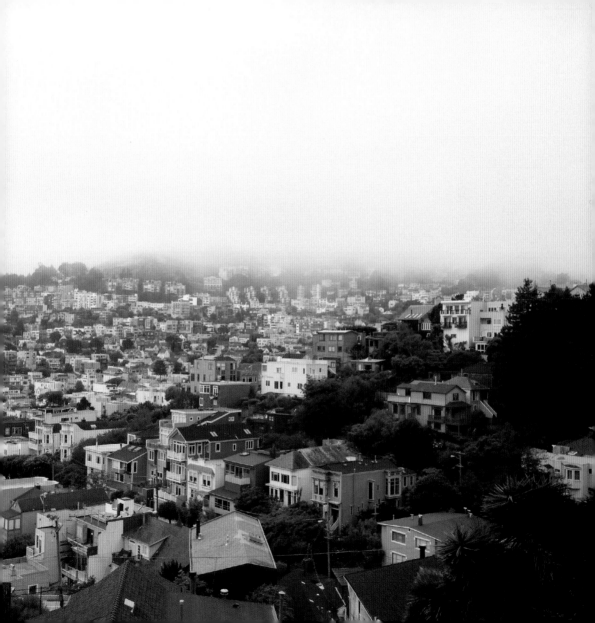

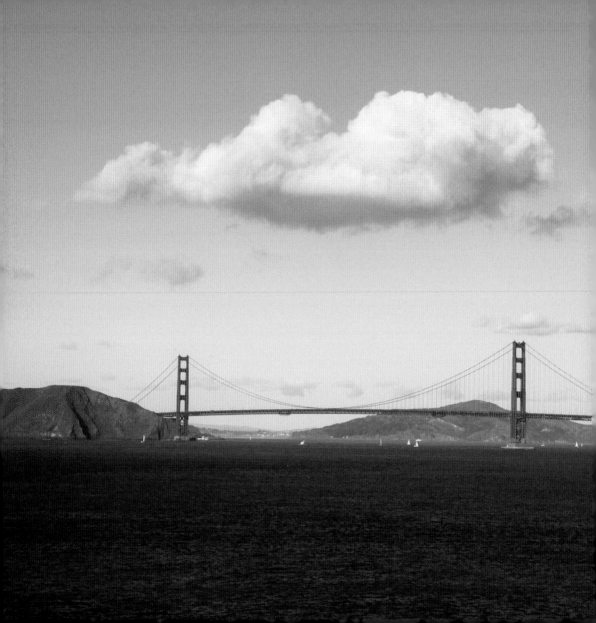

Trolling the Golden Gate Bridge.

Things don't
always seem
as they first a pier.

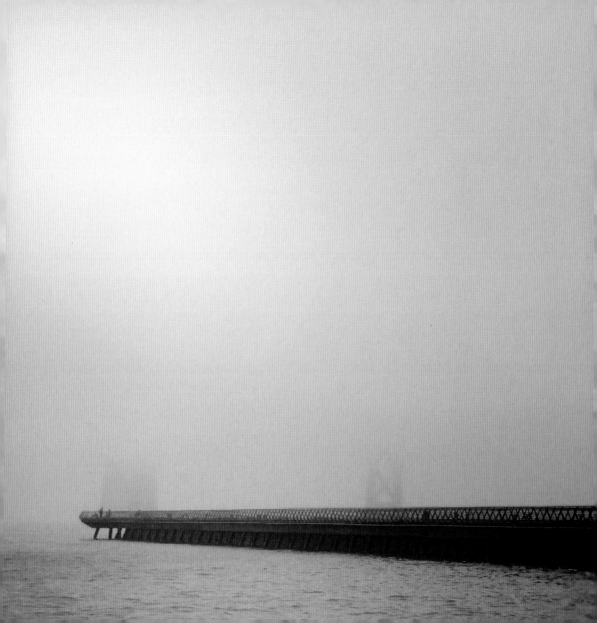

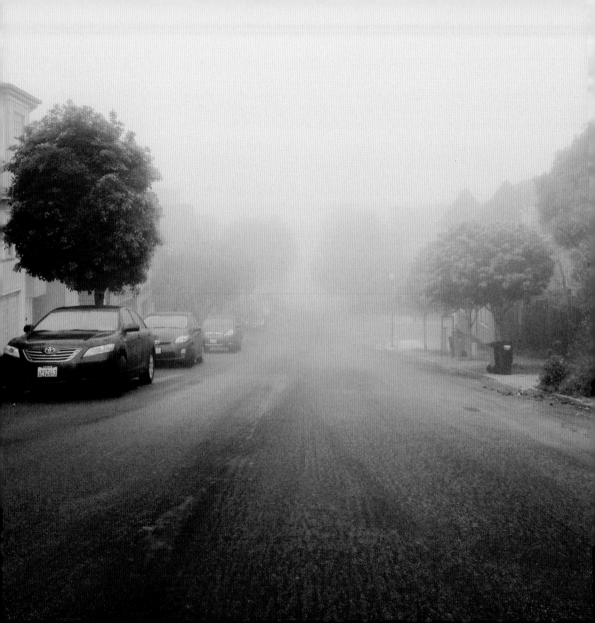

The streets above the Haight
are some of my favorite
places to eat in San Francisco:
you never have to wait, and you
can always eat for free.

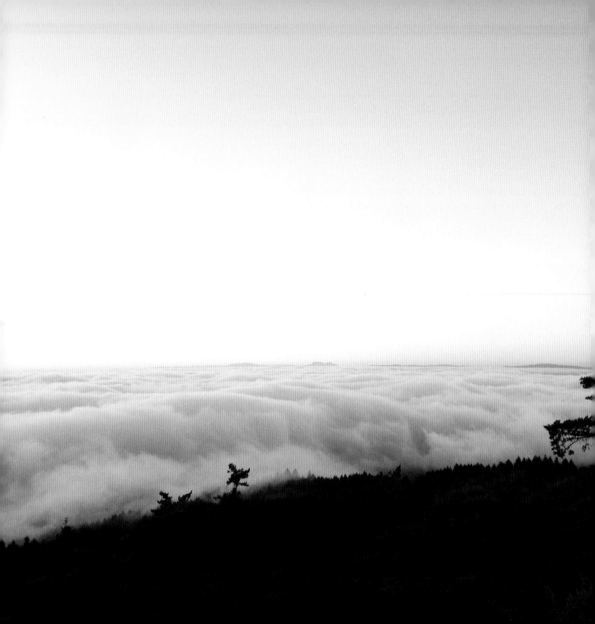

My favorite Halloween costume is dressing up as ocean waves crashing into the shore.

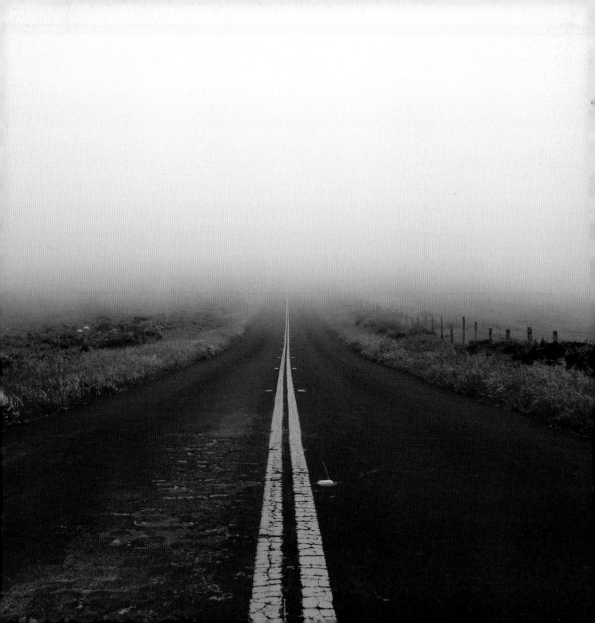

The road to
San Francisco
is paved
with foggy
intentions.

When you interpret
"taste the rainbow"
quite literally.

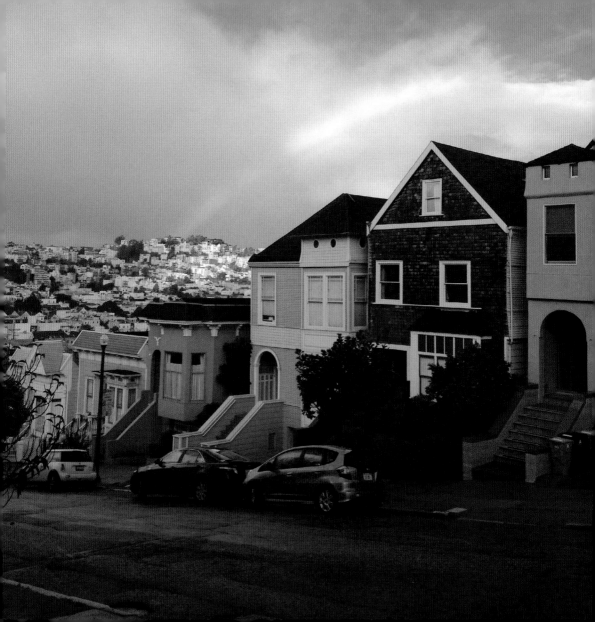

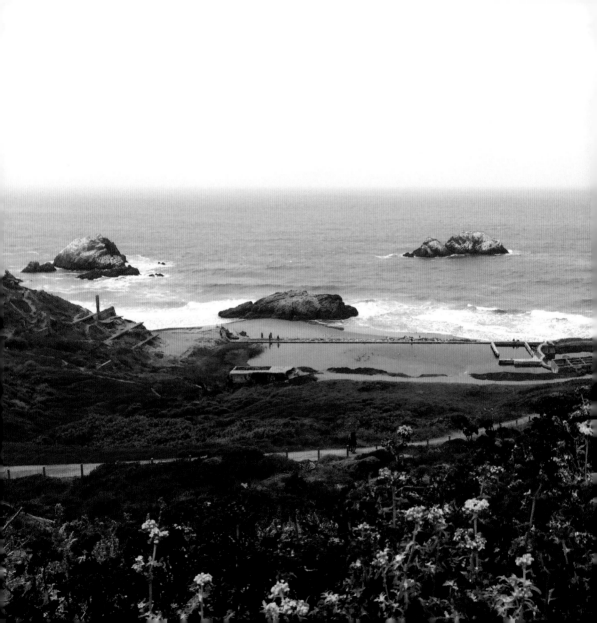

Did you know most
of the flowers at Sutro
Baths were planted
because they specifically
thrive best in me? I think
I read that somewhere.
Don't quote me.

Sutro Tower:
It's my moment to shine.

Me:
Your jokes are funny.

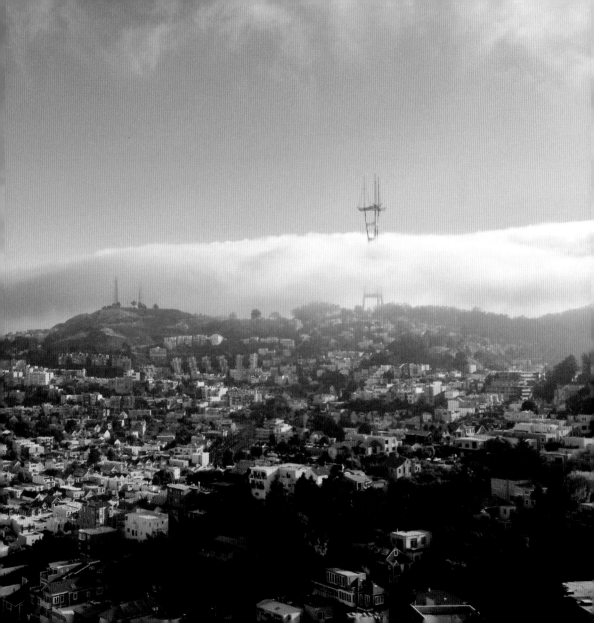

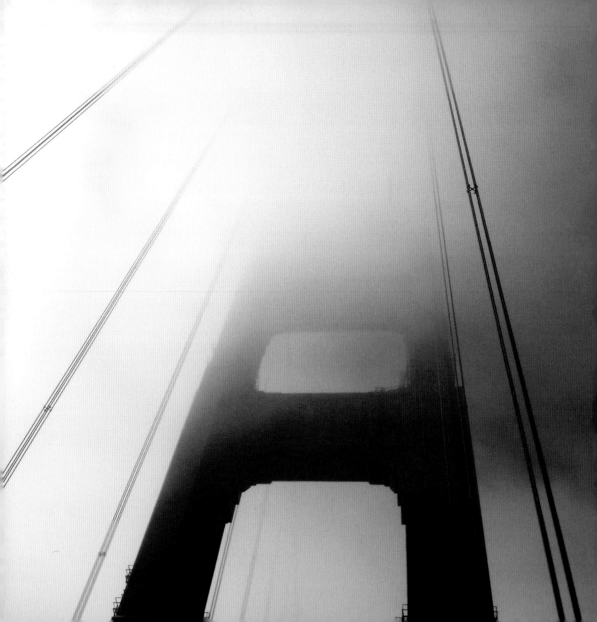

Stuck in traffic on my morning commute.

The birds were trying
to play with me, and
I was not having it.

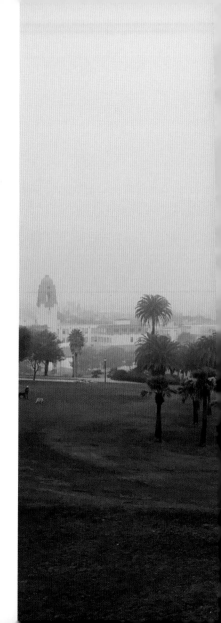

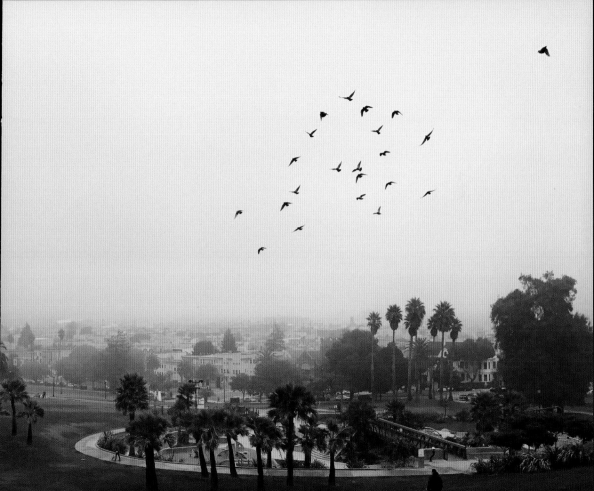

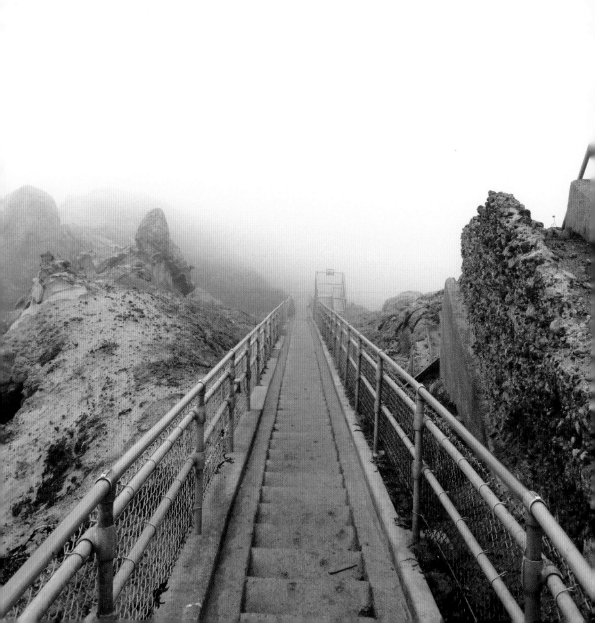

The Point Reyes lighthouse
is so beautiful!

You can't see it?

It's literally right there!

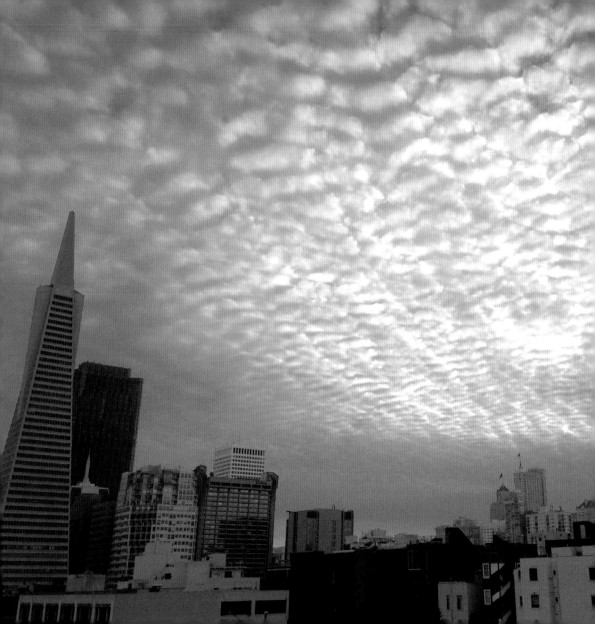

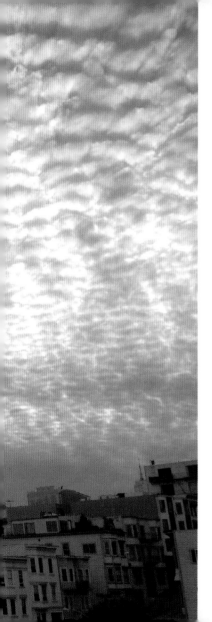

I love charades.

Here I am doing my best impersonation of a quilt.

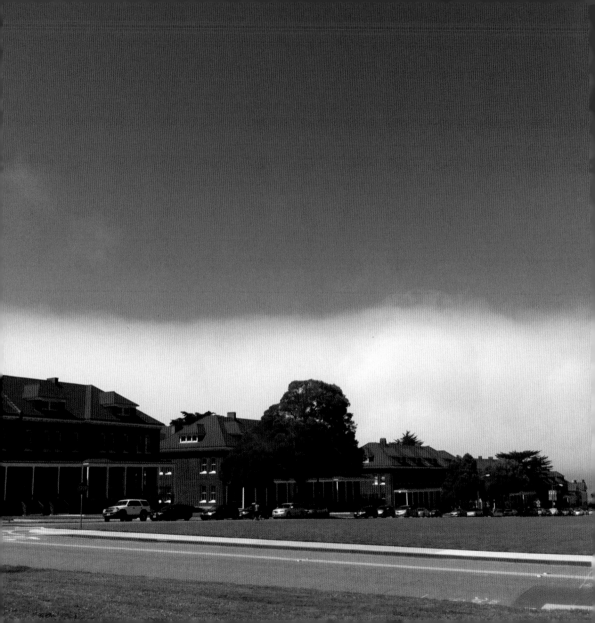

First in line in the Presidio, before the food trucks even arrive.

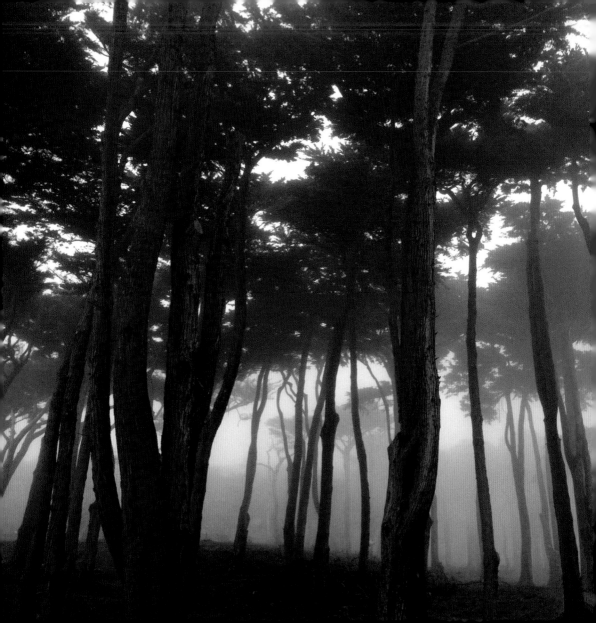

My presence at
Lands End has
inspired at least
three horror
movies.

While my usual style
is to creep slowly
across town, sometimes
I move strong and fast,
cutting a line in the sky.

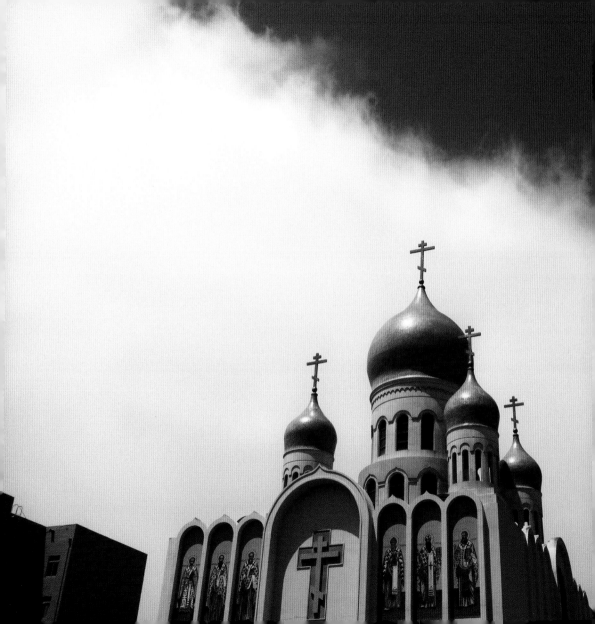

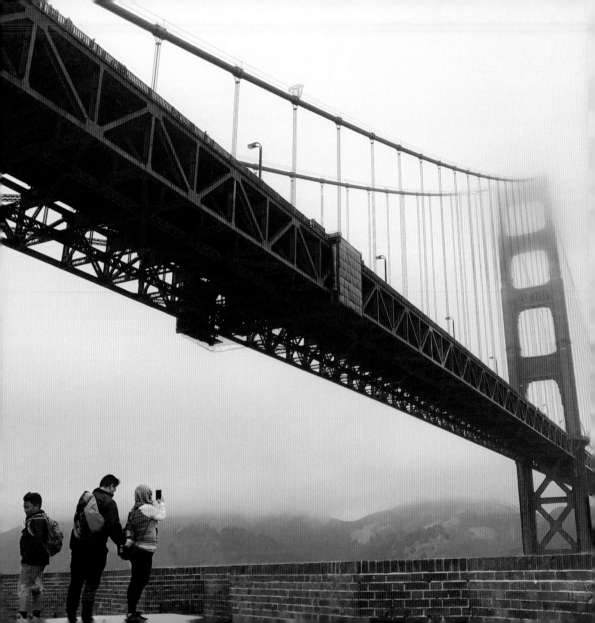

She's clearly
taking a photo
of me.

Definitely not
the bridge.

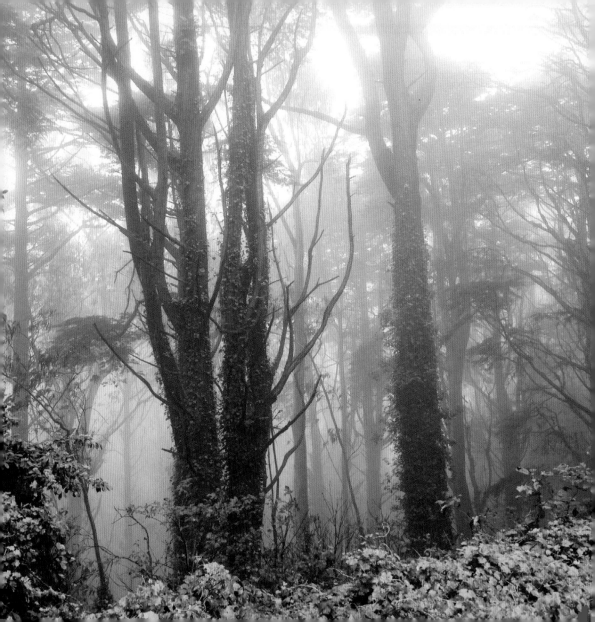

San Francisco
or
Middle Earth?
Hard to say.

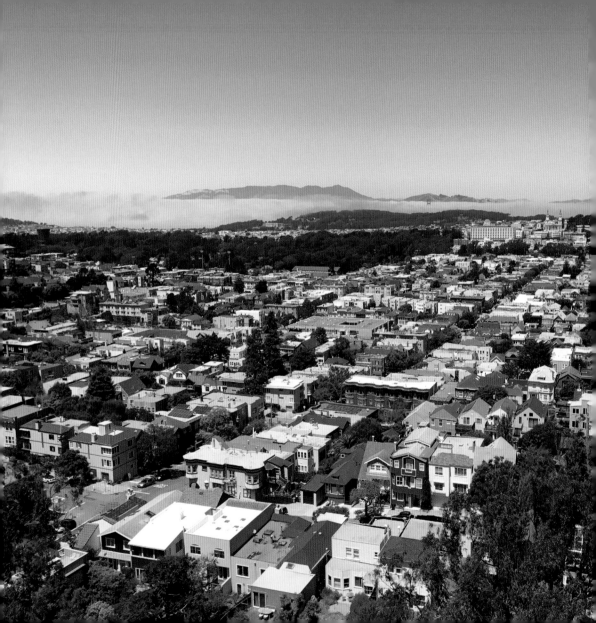

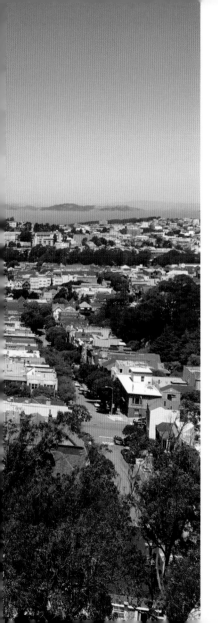

I spend a lot of time
floating near the
University of San Francisco
in hopes that they give me
an honorary doctorate
in Meteorology with an
Attitude.

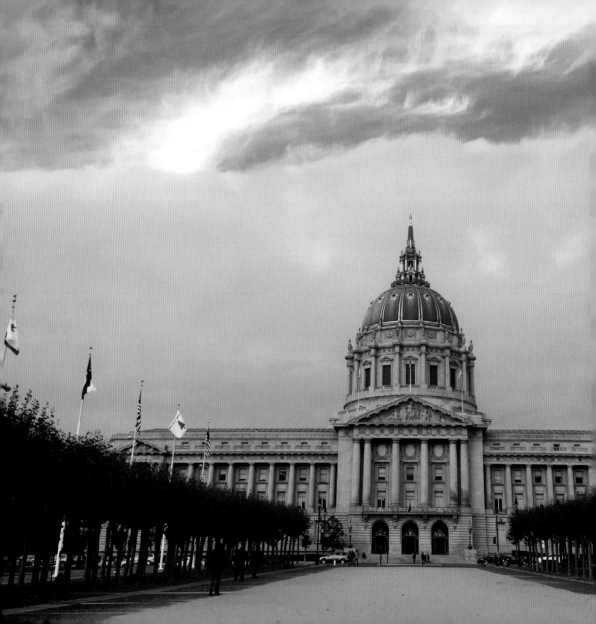

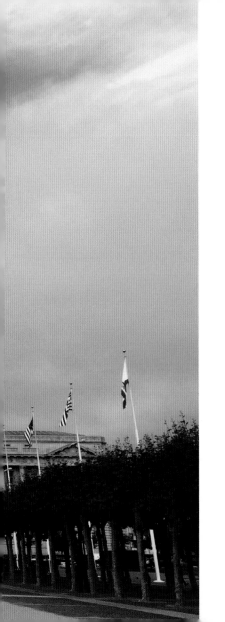

Swinging by
City Hall to vote.

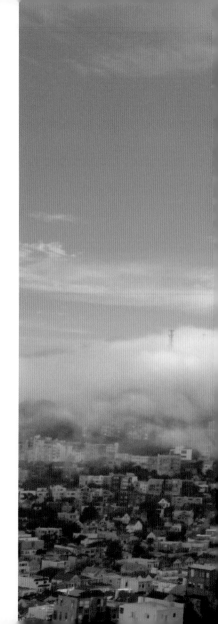

The Fog and the Furious:
San Francisco Drift . . .

a straight-to-video classic
starring Sutro and me.

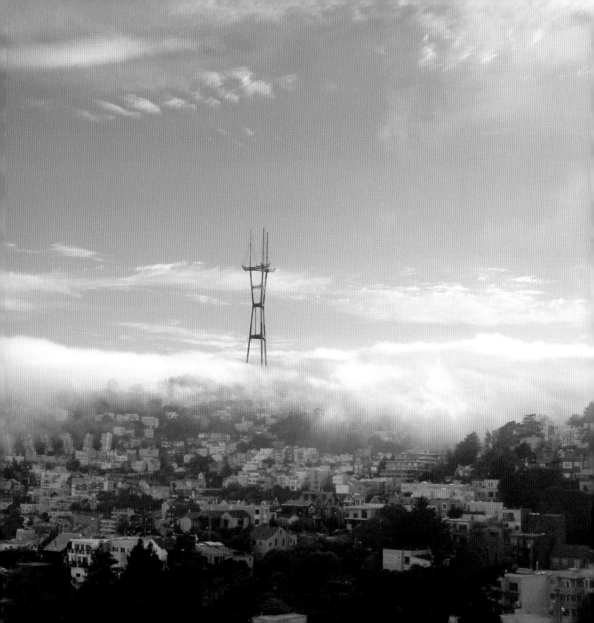

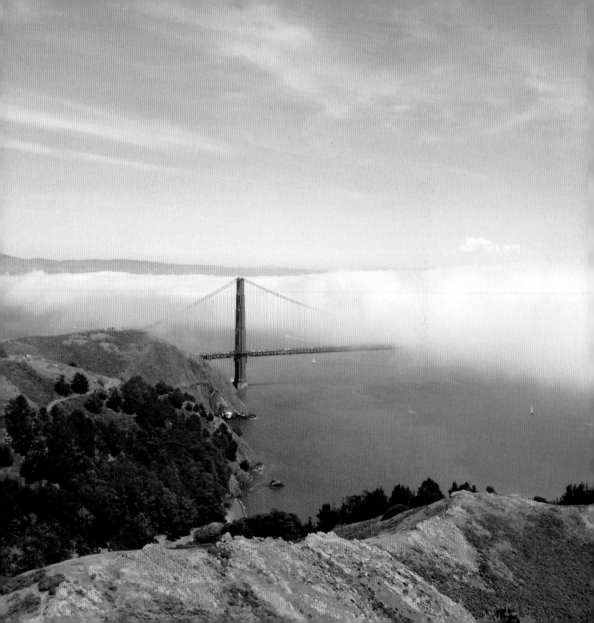

When you eat half your meal really fast and then get full.

I think buildings
look best when
you can barely
see them.

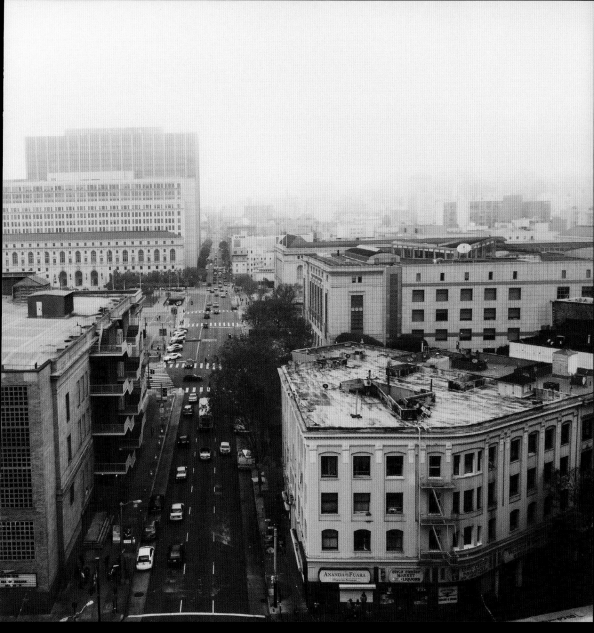

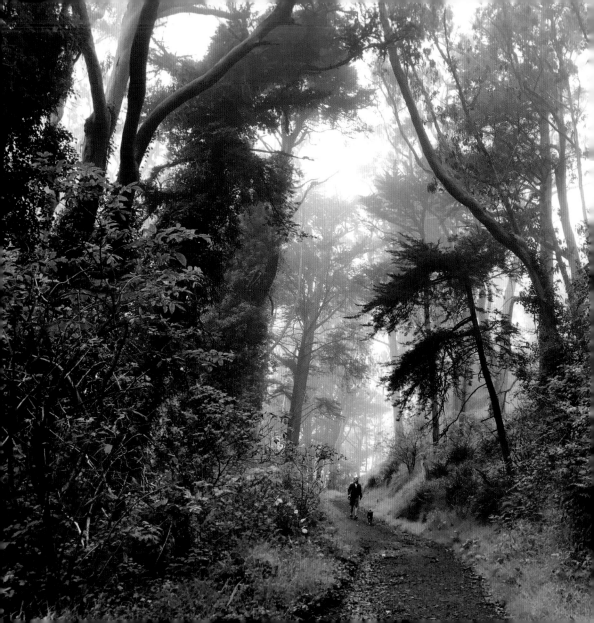

Most people think
of San Francisco as a
concrete jungle, but
there are parts where
you'll think you're
lost in the woods.

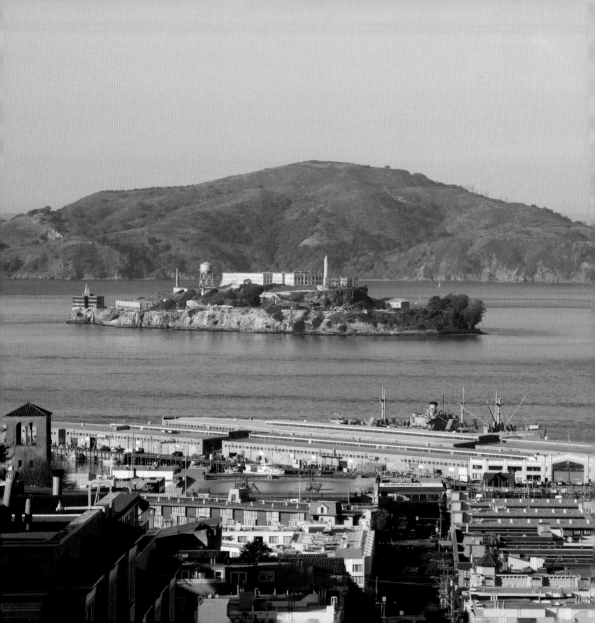

Alcatraz without fog:
a harsh, rocky
prison island.

Alcatraz with fog:
a mysteriously
intriguing dungeon
at sea. Everything's
better with fog.

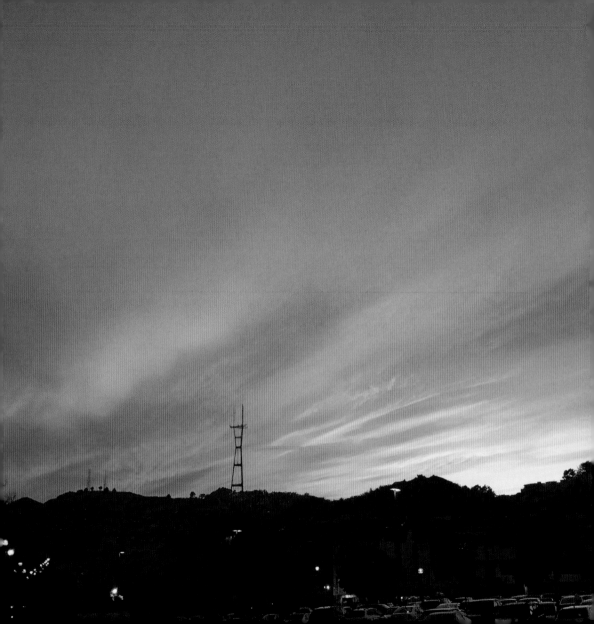

I don't pull this trick often, but sometimes I can make the sky look like it's on fire.

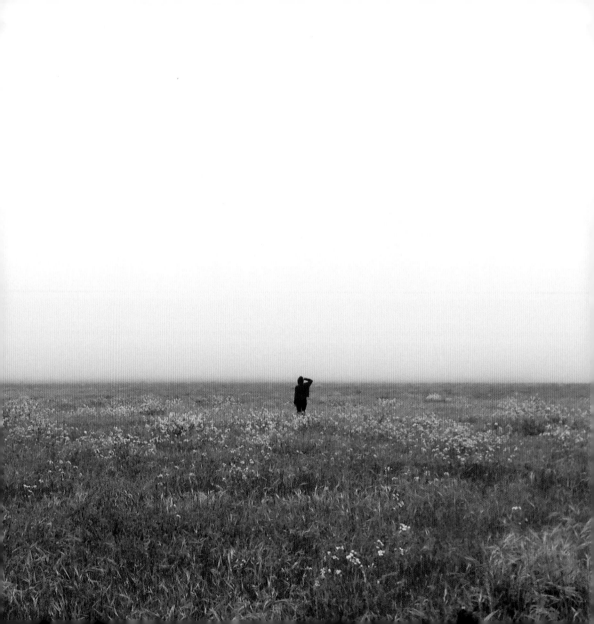

The proper way
to greet me after
several weeks
away is with an
empty field salute.

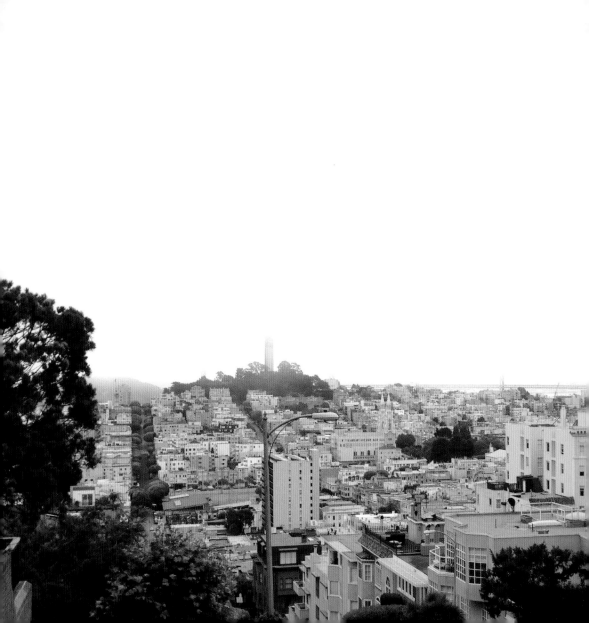

Who needs dry ice
when you've got me
boiling over the hills?

When you fly
thousands of miles
and can't even
see the bridge.

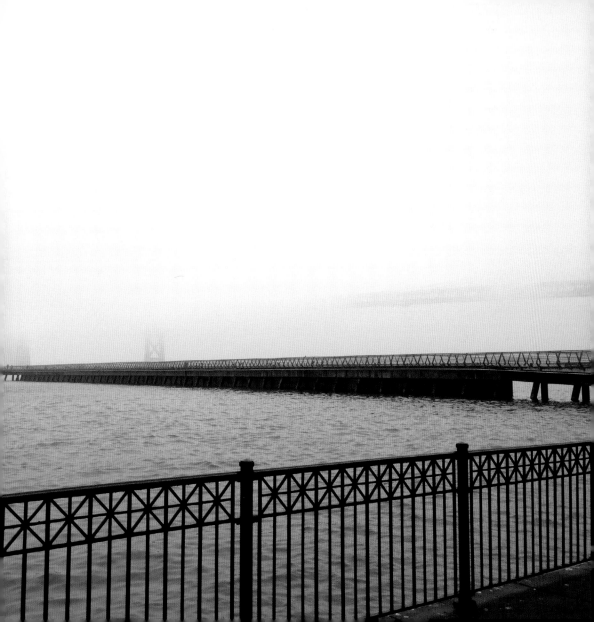

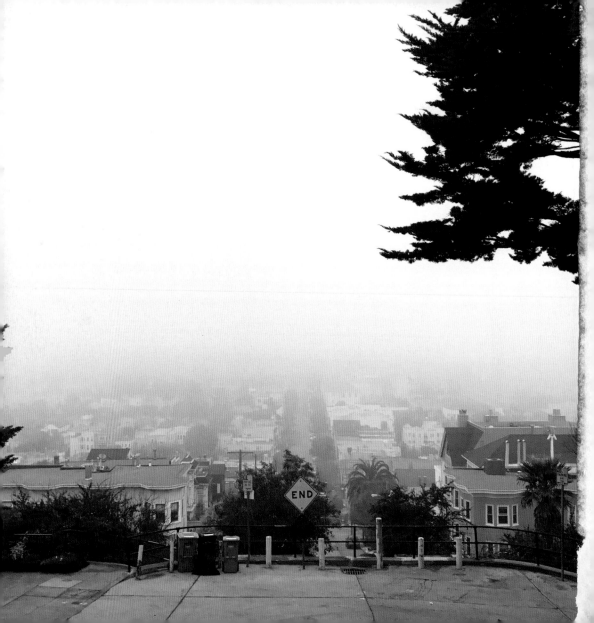